POCKET GUIDES
ALLEGORY

Erika Langmuir

NATIONAL GALLERY COMPANY LONDON

DISTRIBUTED BY YALE UNIVERSITY PRESS

This publication is supported by
The Robert Gavron Charitable Trust

THE POCKET GUIDE SERIES

Angels, Erika Langmuir
Colour, David Bomford and Ashok Roy
Conservation of Paintings, David Bomford
Faces, Alexander Sturgis
Flowers and Fruit, Celia Fisher
Frames, Nicholas Penny
Impressionism, Kathleen Adler
Landscape, Erika Langmuir
Narrative, Erika Langmuir
Saints, Erika Langmuir
Still Life, Erika Langmuir

Front cover and title page:
Michelangelo Merisi da Caravaggio, *Boy bitten by a Lizard*,
1595–1600, 66 × 49.5 cm (49).

First published in Great Britain in 1997 by
National Gallery Company Limited
St Vincent House, 30 Orange Street, London WC2H 7HH
www.nationalgallery.co.uk

ISBN 1 85709 166 3

525235

British Library Cataloguing-in-Publication data.
A catalogue record is available from the British Library.
Library of Congress Catalog Card Number: 97-67664

Edited by Felicity Luard and Nicola Coldstream
Designed by Gillian Greenwood
Reprint typeset by Helen Robertson
Printed and bound in China

CONTENTS

FOREWORD

The National Gallery contains one of the finest collections of European paintings in the world. Open every day free of charge, it is visited each year by millions of people.

We hang the collection by date, to allow those visitors an experience which is virtually unique: they can walk through the story of Western painting as it developed across the whole of Europe from the beginning of the Renaissance to the end of the nineteenth century – from Giotto to Cézanne – and their walk will be mostly among masterpieces.

But if that is a story only the National Gallery can tell, it is by no means the only one. The purpose of this series of *Pocket Guides* is to explore some of the other stories – to rehang the collection, so to speak, and allow the reader to take it home in a number of different shapes and to follow different narratives and themes.

Hanging on the wall, for example, as well as the pictures, is a great collection of frames with their own history, hardly less complex and no less fascinating. There is a comparable history of how artists over the centuries have tried to paint abstract ideas, and how they have struggled, in landscapes, to turn a view into a picture. And once painted, what happens to the pictures themselves through time as they fade or get cut into pieces? And how does a public gallery look after them?

These are the kinds of subject and question the *Pocket Guides* address. Their publication, illustrated in full colour, has been made possible by a generous grant from The Robert Gavron Charitable Trust, to whom we are most grateful. The pleasures of pictures are inexhaustible, and our hope is that these little books point their readers towards new ones, prompt them to come to the Gallery again and again, and accompany them on further voyages of discovery.

Neil MacGregor
DIRECTOR (1987–2002)

INTRODUCTION

A visit to an art gallery specialising in European art – especially one with such a wide-ranging collection as the National Gallery, London – soon reveals that Old Master paintings fall into distinct types such as portraits, landscapes and still lifes, or the broad category of religious images.

Religious images in turn are seen to subdivide into illustrations of the familiar events of the Christian story, such as the Nativity or the Crucifixion of Christ, and timeless scenes like the Virgin Mary holding her infant Son, alone or surrounded by angels and saints. The more popular Christian saints are easily recognisable through the attributes with which they are always

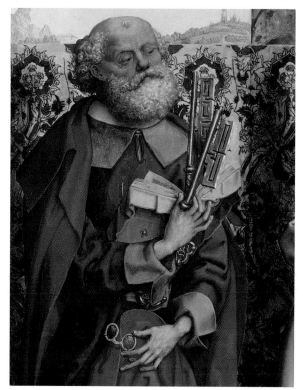

1. Saint Peter, detail from *Saints Peter and Dorothy*, probably 1505–10, 125.7 × 71.1 cm, by the Master of the Saint Bartholomew Altarpiece.

depicted, such as the keys of Saint Peter [1] (from the Gospel of Matthew, 16:19, where Jesus says 'And I will give unto thee the keys of the kingdom of heaven...'), or the spiked wheels [2] on which Saint Catherine of Alexandria was martyred (destroyed by a great burst of flame from heaven, these have given the name 'catherine wheels' to spinning fireworks).

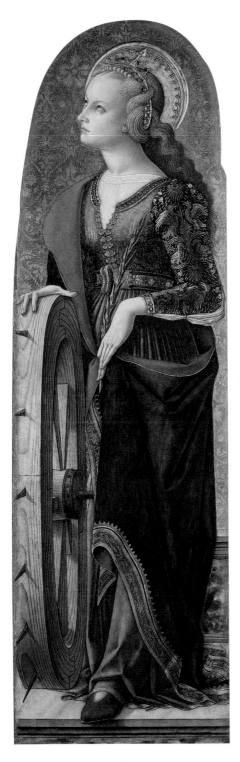

2. Carlo Crivelli,
*Saint Catherine of
Alexandria*, 1476,
137.5 × 40 cm,
from *The Demidoff
Altarpiece*.

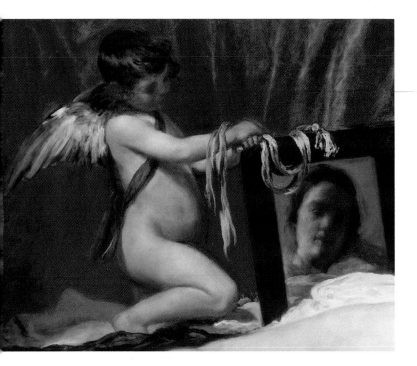

3. Cupid, detail from *The Toilet of Venus ('The Rokeby Venus')*, 1647–51, by Diego Velázquez, 122.5 × 177 cm.

More difficult for the modern viewer are many paintings illustrating episodes from ancient history or the mythological fables told by the Latin poets Ovid and Virgil – at one time required reading for every schoolchild. But although computer studies have ousted Ovid from the classroom, his most frequently represented characters have never been altogether forgotten: Mars, god of war, who lends his name to the 'martial' arts, and his lover Venus, goddess of love and beauty. Best known of all, Venus' mischievous son Cupid [3] and his playmates flutter out of the galleries onto our Saint Valentine's Day cards, shooting arrows into defenceless hearts.

There is another kind of picture, however, which while related to ancient history and fable is now still more difficult to understand and appreciate: allegory, from Greek or Latin words meaning 'speaking otherwise than one seems to speak'.

A good example of an allegorical painting is this work by Pompeo Batoni [4], now chiefly remembered for his portraits of English noblemen stopping off in Rome during their Grand Tour of the Continent. At first sight it seems a strange kind of domestic drama.

A naked old man is pointing angrily at a bemused young woman, while an aged harridan claws at her face. When we look closer, however, we notice that the old man has sprouted wings from his shoulders and holds an hour-glass – the well-known attributes of Time.

Batoni's title for this picture was *Time orders Old Age to destroy Beauty*. In a letter to his patron he boasts that the subject is 'neither from fable nor from history, but of my own invention'. An Italian-speaker would immediately understand why Batoni depicted Old Age

4. Pompeo Batoni, *Time orders Old Age to destroy Beauty*, 1746, 135.3 × 96.5 cm.

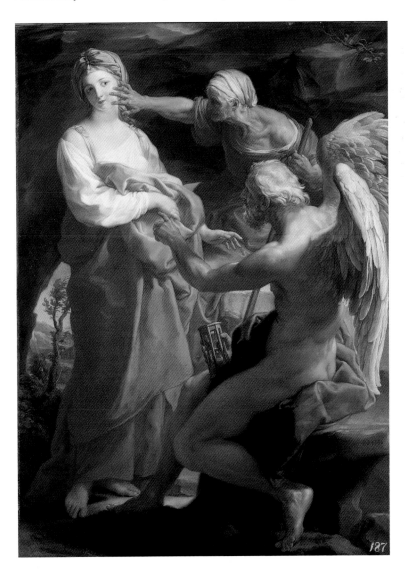

9

and Beauty as women: both are feminine words in Italian – *la vecchiezza*, old age, and *la bellezza*, beauty – while time is the masculine *il tempo* (and even English-speakers refer to 'Father Time'). Batoni believed, as did most artists until the nineteenth century, that large-scale narrative paintings showing the actions and emotions of human figures were the highest form of art. His 'invention' was to make up a dramatic narrative from what is in fact merely a truism: in time, youthful beauty gives way to raddled old age. The abstract notions of 'beauty', 'youth', 'old age' and 'time' are given human form: they are 'personified'.

Personification is a device used in European languages to make abstract notions more vivid: it enables us to imagine that 'time flies', fate has 'a cruel hand' or 'a fickle finger', and love 'is blind'. Once we have created persons out of abstract ideas, we can suggest kinship between them – as in 'Truth is the daughter of Time' or 'Necessity is the mother of Invention'. Like Batoni, we can cast them as characters in an allegorical story.

Painted or sculpted allegories form a category of art uniquely bound to language. Rooted in the propensity of language to personify, visual allegory also relies on other figures of speech: simile (when we call someone 'steady as a rock') and metaphor (when we write of 'the ship of state').

For many hundreds of years art theoreticians and artists believed that the closer art was to language and literature, the better it must be – and not only because of the skill required to depict human emotions and the human body in action. One of the clearest statements of this belief, and of the reasons for it, is by the early eighteenth-century English portrait painter Jonathan Richardson:

The Great Business of Painting I have often said... is to relate a History, or a Fable, as the best Historians, or Poets have done... [purely pictorial qualities] are the Mechanick Parts of Painting, and require no more Genius, or Capacity, than is necessary to, and frequently seen in, Ordinary Workmen; and a picture, in this respect, is as a Snuff-Box, a Fan, or any other Toy...

Since time immemorial, manual dexterity – the 'Mechanick Part' of human activity – has been felt to be inferior to intellectual effort. We still tend to prize imaginative 'fine art' above 'mere craft'. But as Richardson implies, the reluctance of painters in past centuries to be classified among 'Ordinary Workmen' was also rooted in a moral objection. While artisans catered to the greed and frivolity of the rich with snuff-boxes, fans and other toys, 'the best Historians, or Poets' moved hearts and minds. By offering up examples of virtue, they had the power to influence people to *be* good and to *do* good.

This view, first expounded by ancient Greek and Latin authors, persisted through the fall of pagan Rome and the rise of Christianity, which gave it even greater force by using art as the vehicle for Christian doctrine and the focus of Christian worship. At various times throughout Europe this moral repugnance to 'mere craft' also had practical consequences. The work of craftsmen attracted heavy taxes, while that of writers, notaries, mathematicians, musicians and so on did not. Thus we find painters arguing the intellectual dignity of their art at least in part for financial reasons. And there was no better argument than to 'relate a History, or a Fable' with the brush, or to depict 'universal truths' in painted allegory. Even poets agreed that images could be more striking and more memorable than words: when Charity, the 'mother of all virtues', is shown nursing a happy brood of babies and toddlers [5], the very essence of the idea is communicated.

5. Charity, detail of 22.

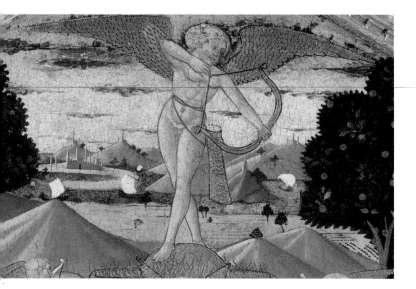

Paradoxically, the equally noticeable ambiguity of images when compared to the precision of words – a picture's inability to distinguish between 'My cat is sitting on a mat' or 'Once upon a time a cat sat on a mat' – was seen by some as an additional advantage. In the Renaissance, the mysterious pictographs of ancient Egyptian hieroglyphics (not deciphered until after the discovery of the Rosetta stone in 1799) were thought to be symbolic images in which sages had encoded esoteric mysteries. Similarly, pictorial allegory could be viewed as an occult language, embodying a 'higher' reality but revealing it fully only to initiates.

Even in antiquity, pagan myths were understood by many to have allegorical significance, and the line between a pagan divinity and a personification has always been a fine one: Mars, god of war, can represent war itself, just as 'Love's sharp arrows' are fired by Cupid [6]. Equally familiar to those with a classical education were the heroes and heroines of ancient history, exemplars of various virtues such as justice, clemency, fortitude or chastity.

The 'vocabulary' available to painters of allegory, however, continued to grow over the centuries. The pagan gods of antiquity survived the rise of Christianity by being identified with celestial bodies. Their displacement from religion to astrology is recorded in such expressions as 'jovial', 'mercurial' or 'saturnine',

characterising people who have come under the planetary influence of Jove (Jupiter), Mercury [7] or Saturn.

In the medieval period – when many encyclopaedic treatises and poems were written in allegorical form – virtues and vices also acquired their own personifications, distinct from the ancient gods. The frequently represented Liberal Arts, such as grammar and logic, are also a medieval legacy, as are the cycles of the seasons and the months of the year. To such schemes were added the Five Senses, the Ages of Man [8] – which in turn could be related to the times of day and the seasons – the elements, and so on. There were also images drawn from the Bible, and those suggested by observation of the natural world and of society.

7. Mercury, detail of 18.

8. Maturity, detail of 62.

No wonder that by the end of the sixteenth century handbooks had been compiled for the use of artists, who (despite their claims to the contrary) were not generally well-educated, and in any case could hardly be expected to comb the whole of literature, philosophy and theology for source material. The most influential of these handbooks was the *Iconologia* of Cesare Ripa, first published in 1593 and translated, amplified and republished many times since.

THE PAGAN GODS

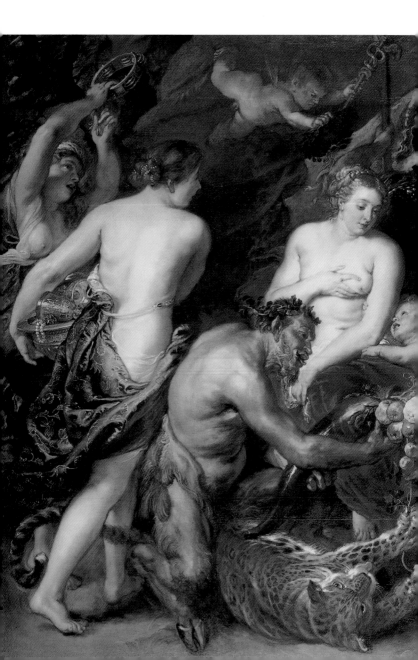

A ncient Graeco-Roman mythology was perhaps the richest and most versatile source of allegorical imagery, and the one most popular with Renaissance and later artists. Pagan deities could convey messages for the public good, or flatter pleasure-loving princes and courtiers. They could gratify dynastic pride or embody astrological lore. All these aspects of allegory based on pagan myth are illustrated in the paintings discussed in this section.

9. Peter Paul Rubens, *Minerva protects Pax from Mars ('Peace and War')*, 1629–30, 203.5 × 298 cm.

Peter Paul Rubens, collector, scholar, and twice-knighted diplomat, was probably the greatest painter of allegory in the history of art. Few artists since the Middle Ages have been more dedicated to communicating ideas through visual images. 'Those things which are perceived by the senses,' he wrote, 'produce a sharper and more durable impression, require a closer examination and afford richer material for study than those which present themselves to us only in the imagination.'

In 1628–30 Rubens undertook his most important diplomatic mission: to procure peace between Spain and England. His negotiations successfully concluded in the summer of 1629, he was delayed in London and found time to practise his 'beloved profession'. In 1630 he presented *Minerva protects Pax from Mars*, or the *Allegory of Peace and War* [9], to King Charles I, as a deliberate attempt to maintain that picture-loving monarch's enthusiasm for peace.

Like all allegories, *Peace and War* requires decoding, although even minimally educated contemporaries would have had little difficulty in identifying most of Rubens's personifications, drawn from classical mythology and made familiar by pictorial tradition. But Rubens's paintings are never bloodless picture-puzzles, and even a twenty-first-century viewer, who may miss some of the allusions, readily grasps this picture's central message.

10. Susan Gerbier, detail of 9.

Rubens must have intended our gaze to be drawn by the lustrous glance of the little girl who stares trustingly out of the canvas – the only figure to do so. She is a real child: Susan, daughter of Rubens's host in London, the painter and royal agent Balthasar Gerbier. Dressed in contemporary seventeenth-century clothes, she seems to hesitate before popping a grape into her mouth.

Susan's brother George, in the guise of the torch-carrying Roman god of marriage, Hymen,

reaches over her to crown their older sister Elizabeth. The girls are urged forward by an adolescent Eros (perhaps an earlier, less readily recognisable, portrait of George).

We, who can see what is happening behind them, tremble for these innocent beings. Only the forceful intervention of helmeted Minerva, the goddess of wisdom, protects them from the baleful god of war, Mars, black-armoured and cloaked in blood red, and his attendant, Fury. Their side of the picture has been put to the torch, all smoke and smouldering fires. Susan's direct appeal mobilises our instinct to preserve the children's fragile happiness, to help Minerva defend the golden realm they inhabit: that of Peace, invoked by the Greek poet Hesiod as 'Protector of Children'.

Peace is the radiant mother squirting milk from her breast to nourish the infant Plutus, god of wealth. A winged child holds two emblems of peace above her head: a crown of olive and Mercury's snake-wreathed messenger's staff, the caduceus.

The followers of Bacchus, god of wine and fertility, celebrate the blessings of Peace. A bacchante dances to a tambourine, another brings forward a basin full of pearls and golden vessels. A bronzed satyr (for Rubens a figure of animal exuberance rather than lust) proffers a horn of plenty filled with the fruit of orchards and vineyards. Bacchus' leopard plays like a kitten with tendrils of vine, and another winged child offers the sweet fruit to Gerbier's daughters.

Nature and humankind can prosper, flourish and multiply, if only Minerva/Wisdom succeeds in keeping Mars/War at bay.

While Rubens, in 1630, devised *Peace and War* with all the vividness of a narrative 'to produce a sharper and more durable impression' of the message already conveyed through his diplomatic work, Bronzino's aims, in *An Allegory with Venus and Cupid* [13], painted in the 1540s, are more ambiguous.

Bronzino had become chief painter at the hierarchic and despotic Florentine court of Duke Cosimo I de'Medici, and his style had modified accordingly. Although he was still capable of fidelity to nature, as in his portraits of Cosimo's children, his other works were marked by ostentatious artifice and aristocratic aloofness – none more so than this *Allegory*.

The picture may have been planned from the beginning as a diplomatic present from Cosimo to King Francis I of France, as famous for his superficial love of Italian art as he was for his lusty appetites. Alternatively, it may have originated in a tapestry design for Cosimo's new Florentine tapestry-works. Designers of tapestries often emphasised the surface patterns of their luxurious wall coverings, minimising – as Bronzino does here – the distinction between 'figure' and 'background'.

In either case, the painting would have made a suitable gift for Francis and his courtiers. Its puzzling character would have appealed to them just as much as its nudity and eroticism, both justified through reference

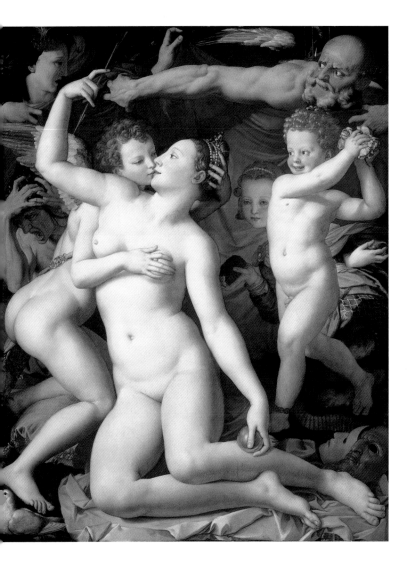

to Graeco-Roman antiquity. The stylishness of the jewelled accessories, and the costliness of the ultramarine in the magnificent blue drapery, would have been additional attractions.

Whatever its precise origins and significance, the *Allegory* was surely intended for a special kind of private viewing – to flatter, titillate, and tantalise the (male) viewer. In addition to figures from pagan mythology, it includes personifications probably invented by Bronzino himself.

13. Bronzino,
An Allegory with Venus and Cupid,
probably 1540–50,
146.1 × 116.2 cm.

19

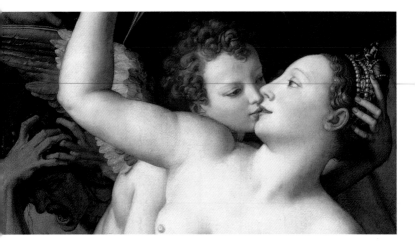

14. Venus and Eros, detail of 13.

In the centre foreground of Bronzino's *Allegory*, Venus is lasciviously embraced by her son Cupid (in this adolescent form more properly called by his Greek name, Eros). In her left hand Venus holds the golden apple awarded her in the mythological Judgement of Paris; with her right she draws an arrow from Eros' quiver. The act is itself enigmatic: some have read it as the Triumph of Beauty over Love, but as Venus herself (on close examination of tongue and nipple) seems no less sexually aroused than Eros, this cannot be the moral of the picture. Eros kneels on a silken cushion, an attribute of Lust (*Luxuria* in Latin, the source of our word 'luxury'). Below is one of the doves that draw Venus' chariot. At the goddess's feet are two masks, perhaps those of a satyr and his eternal quarry, a nymph.

Foolish Pleasure, the laughing child with a morris dancer's anklet of bells, throws rose petals at Venus and Eros, heedless of the rose thorn piercing his right foot. Behind him Deceit, with a girl's beautiful face but a monster's body beneath her green gown, proffers a honeycomb in one hand, concealing a scorpion's sting in the other. Her hands may be reversed, although viewers disagree about this. Pleasure and Deceit abet lustful love.

On the other side of the lovers is a dark figure, screaming and tearing at its hair. It has been variously identified as Jealousy, Despair or the personification of syphilis, the venereal disease newly introduced to Europe. The former interpretations depended on it being seen as a female figure, while the latter hinges on it being a male one. Yet it seems improbable that a personification of

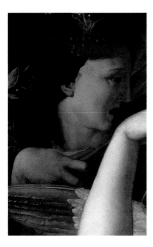

syphilis, called by Italians 'the French disease' because it was spread throughout Italy by invading French troops, would have been included in a painting for the King of France. Because of its close resemblance to engravings of *Dolor* (the masculine Latin word for Pain), this figure may be a general image of all the painful consequences of unchaste love.

Above, a part-headless figure – probably Oblivion, for she lacks those parts of the brain where memory was thought to be stored – tussles with Time; we recognise him by his white beard, his hourglass and his wing. Most viewers agree that she is attempting to draw the ultramarine veil over the central scene, while he fiercely prevents her from doing so. It has been suggested that this is a reference to the long periods of remission, and the latent effects, of syphilis, but it is probably of wider application.

16. Foolish Pleasure and Deceit, detail of 13.

At once alluring and repellent, lubricious and censorious, legible and obscure, hot and cold as polished marble, full of action yet perfectly static, the picture recalls the poetry of the period. This often relied on oxymoron – the conjunction of contradictory terms to produce a striking effect, as in 'icy fire' or 'beautiful tyrant' – and sought formal perfection while expounding the cruelty of beautiful women and the pangs of love. Bronzino, like Michelangelo, was a poet, and perhaps the true meaning of this endlessly fascinating painting resides in its resemblance to its sister art: a painting like a poem.

The great eighteenth-century Italian decorative painter Giovanni Battista Tiepolo has been called the 'last painter of the Renaissance'. In his *Allegory with Venus and Time* [17], of about 1754–8, he depicts some of the protagonists of Bronzino's picture, but to very different ends, demonstrating both the versatility of pagan deities and the dangers of a mechanical, 'dictionary' reading of allegorical figures, whose significance depends so heavily on context.

This shaped canvas was painted to be inserted into the plaster moulding of a ceiling, in a room, perhaps a bedchamber, of one of the many Venetian palaces of the Contarini family. It was designed to be seen from below, but at an angle, as from a bed against one of the walls.

Venus has swooped down in her chariot through luminous skies. Her team of doves, released from harness, flutter lovingly above her. From a dawn-tinted cloud, her handmaidens, the Three Graces, strew roses. These associated deities of gratitude, sociability and friendship also signify beauty arousing desire and leading to fulfilment. Winged Cupid, Venus's divine son, hovers below with his quiverful of arrows. Venus has apparently come to consign another child, newly born and freshly washed with water from her amphora, to Time. Having set down his scythe, Time symbolises eternity rather than mortality. The wide-eyed infant, full-lipped and with a widow's peak, is clearly meant to be a real, not a mythical, baby.

Venus's only mortal child was Aeneas, the mythical founder of Rome. One of the oldest families in Venice, the Contarini claimed ancient Roman lineage. A painting of Venus consigning Aeneas to Time may thus have been commissioned to celebrate the birth of a son, or as a bridal ceiling decoration in the joyful anticipation of such a birth. The latter is more probable: there is no record of a Contarini boy being born around this time, and the painted child is held above the earth, not yet descended on to it. Under the influence of Venus, Cupid and the Three Graces, newlyweds should rapidly produce an heir, who, through august parentage and his own heroic deeds, would, like Aeneas, win eternal fame.

17. Giovanni Battista Tiepolo, *An Allegory with Venus and Time*, about 1754–8, 292 × 190.4 cm.

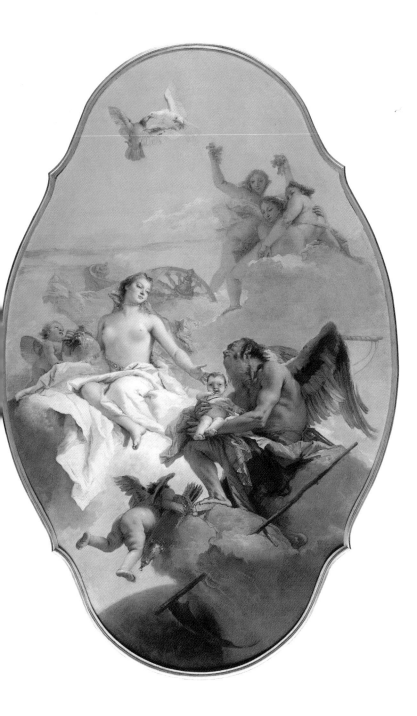

18. Correggio,
*Venus with
Mercury and
Cupid ('The
School of Love')*,
about 1525,
155.6 × 91.4 cm.

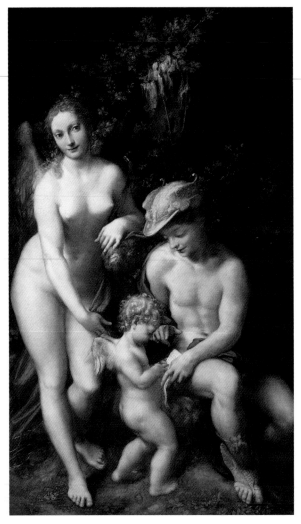

ALLEGORY AND
ASTROLOGY:
VENUS, CUPID
AND MERCURY

An even more benevolent image of the goddess of love and beauty is projected by Correggio in *Venus with Mercury and Cupid ('The School of Love')* of about 1525 [18]. It is one of six erotic canvases on mythological themes painted by the artist for Federigo II Gonzaga, Lord of Mantua and, like Francis I, a notorious womaniser. Its probable companion picture [19], now in the Louvre, shows a satyr uncovering a nude woman sleeping in sensuous abandon on the ground; she is more likely to be Venus than a mere nymph.

While four of Correggio's pictures for Federigo represent the Loves of Jupiter, as retold by Ovid, these

two paintings do not relate to a specific myth. The conjunction of Venus and Mercury in the National Gallery canvas and the contrast between the winged London Venus and her earth-bound sister in Paris suggest that both pictures reflect astrological lore. Correggio would not, however, have needed to have read abstruse texts to invent these designs, just as his patron could appreciate them without any special erudition. Even today, were we able to see the two pictures together, their general meaning would, I think, be vividly clear. They depict two extremes of human sexuality: carnal passion on the one hand, and the affective and civilising bonds of love on the other. Nevertheless, it would be wrong to read the London picture as representing an idealised nuclear family.

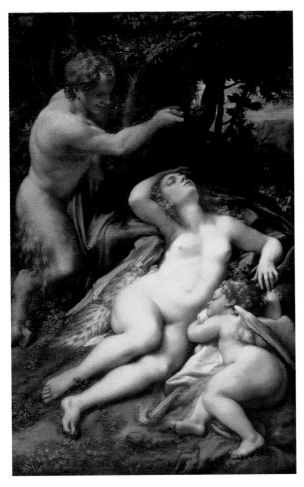

19. Correggio, *Venus, Cupid and a Satyr*, about 1525, 188 × 125 cm. Musée du Louvre, Paris.

Correggio's more scholarly contemporaries might have entitled the pictures 'Terrestrial Venus' and 'Celestial Venus'. The 'Celestial Venus' personifies the planet that influences those born under her zodiacal sign to be of a friendly, amiable disposition, to love grace and finery, and to embrace the ideals of refinement and culture. In this astrological realm, Mercury – pagan deity of eloquence and the gods' messenger – replaces Minerva as the protector of the arts and sciences. Representing, in the words of a fifteenth-century Florentine, 'good counsel, reason and knowledge', the planet Mercury 'governs' not only orators but also scholars and artisans, artists and merchants.

In the London painting these two kindly beings unite to domesticate and instruct Cupid, the unruly and disruptive god of love. As X-rays reveal, Correggio changed the position of Venus's head. Where once she also looked down at her son, she now addresses the viewer, no less seductive than her sleeping twin in the Louvre. Thanks to Correggio's brush, Federigo did not need to choose one Venus and reject the other, but was able to embrace each in turn and at will.

20. Head of Venus, detail of 18.

Like Bronzino, Correggio seems to have taken delight in painting nudes. In contrast to the younger Florentine, he chose to give his figures the appearance of life rather than that of ancient marble, lending motion even to limbs at rest, soft iridescence to flesh and hair, feather and fur. Seen in the Gallery, the 'School of Love' is more often enjoyed than 'read' as an improving allegory.

THE
VIRTUES AND VICES

While pagan deities, whether derived directly from ancient texts or filtered through astrology, came to be used from the Renaissance onwards to represent moral qualities, the Middle Ages evolved a separate tradition of representing the virtues and vices.

The principal Christian or 'theological' virtues are Faith, Hope and Charity, outlined in Saint Paul's first apostolic letter to the Christians of Corinth (1 Corinthians 13:13): 'And now abideth faith, hope, charity, these three; but the greatest of these is charity.'

The medieval Church also sanctioned the 'cardinal' virtues of the ideal citizen formulated by the ancient Greek philosopher Plato (*The Republic*, 4:427 ff.): Justice, Prudence, Fortitude and Temperance.

Personifications of all Seven Virtues – sometimes paired with, or triumphant over, their contrasting Vices, or associated with the Seven Liberal Arts – were often sculpted on church portals and pulpits, or painted in chapels and chapter houses. They also appeared in secular public venues such as town or guild halls. From such prestigious locations the Seven Virtues quickly migrated to private houses, as mural decoration or as easel paintings.

Saint Paul defined charity as the principal of the three theological virtues. Early Christian theologians called it 'the mother of all the virtues', while Saint Augustine saw it as the bond connecting man with God. Although Saint Paul had made it clear that the primary object of charity is God, most later definitions distinguished two elements that together make up charity: love of God, and love of one's neighbour (*misericordia*, or mercy) for the sake of God.

This dual character of charity influenced its representations in medieval art. The love of God came to be personified by a figure holding a flame, or a flaming heart, while love of one's neighbour was exemplified through one or more of the Seven Works of Mercy: clothing the naked, feeding the hungry, giving drink to the thirsty, nursing the sick, welcoming strangers,

27

visiting prisoners, burying the dead. This tradition persisted through the seventeenth century, especially in pictures commissioned by charitable confraternities.

In the fourteenth century, the Italian sculptor Tino da Camaino invented a new way of showing both aspects of charity, by personifying her as a mother with two suckling infants. From that time, the attractive figure of the loving mother – usually, as in the paintings illustrated here, with three or more children, and giving suck to only one – became the accepted allegorical representation of Charity.

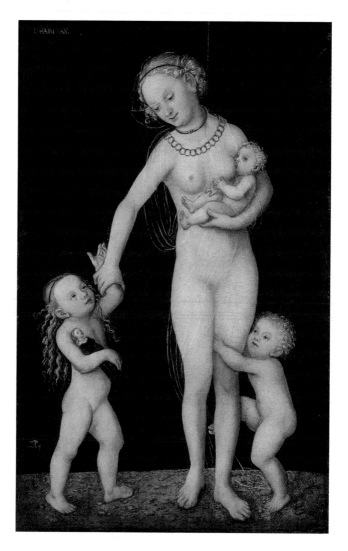

22. Michele Tosini, *Charity*, probably about 1570, 24.5 × 17.8 cm.

Three easel pictures in the collection testify to the popularity of this image north and south of the Alps: *Charity*, 1550–1, by the German painter and friend of Luther, Lucas Cranach the Elder [21], *Charity* of about 1570 by the Florentine Michele Tosini, and *Charity* by Anthony van Dyck, painted in Antwerp soon after the artist's return home from Italy in 1627.

To avoid ambiguity, Lucas Cranach inscribed his little panel *Charitas*. As in all his paintings of allegorical or mythological subjects for collectors, the figures are nude, or scantily veiled, in the 'ancient mode', but adorned with jewellery and hairstyles fashionable in sixteenth-century Germany. Unusually, Cranach depicts one of Charity's lively children as a little girl. She follows the good example of her mother, tenderly carrying a realistic – and fully clothed – doll of the period.

In Michele Tosini's *Charity* [22], the virtue wears a fanciful headdress inspired by Michelangelo's drawings

of imaginary women, the so-called *teste divine*. She has
been suckling one of her babies. The fire, bottom left,
refers to the ardour of her love for God, while the two
children embracing each other symbolise *misericordia*,
'love of one's neighbour' – 'one's nearest'.

The ecstatic heavenward glance of Van Dyck's *Charity*
[23] symbolises the primary component of the virtue:
the love of God, the bond between man and God. The
composition was engraved and became very famous.

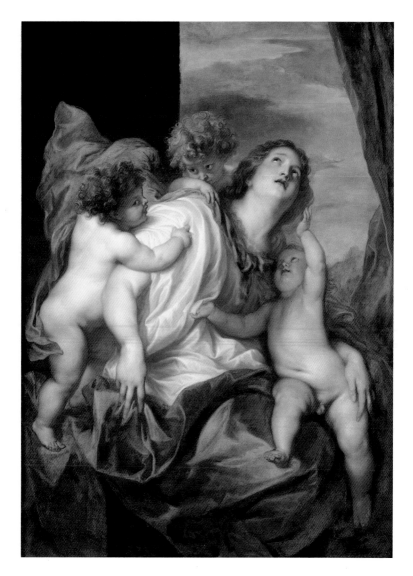

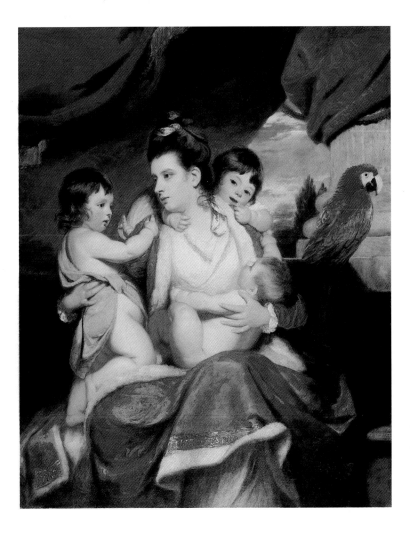

The painting itself may have inspired Sir Joshua Reynolds's portrait [24] of *Lady Cockburn and her Three Eldest Sons* of 1773, also in the National Gallery. Like Jonathan Richardson, Sir Joshua believed that 'the great Business of Painting is to relate a History or a Fable'. Given that virtually all his commissions were for the less prized 'face painting', he liked to demonstrate his 'Genius' by alluding in his portraits to ancient sculpture or to Italianate models such as Van Dyck's allegory.

24. Sir Joshua Reynolds, *Lady Cockburn and her Three Eldest Sons*, 1773, 141.6 × 113 cm.

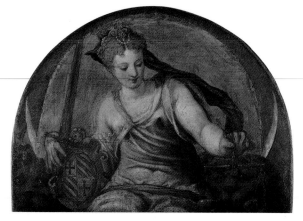

25.
Giuseppe Salviati,
Justice, probably
about 1559,
87 × 104.8 cm.

THE CARDINAL
VIRTUES:
JUSTICE

Justice is the principal of the four cardinal virtues prescribed by Plato, underlying the harmonious working of the other three. Thanks to her presence in courts of law, she remains the best-known personification of the virtues.

In this painting by the Venetian Giuseppe Salviati [25] she is represented with two of her well-known attributes: the sword symbolising power and the scales signifying impartiality (but not the blindfold reinforcing impartiality, which was added to her likeness in the sixteenth century). The lions may also be her attributes. Since this picture was commissioned for the Venetian mint, however, they may refer to the emblem of Venice: the lion of Saint Mark, the city's patron.

The coat of arms supporting Justice's sword-bearing arm is that of a branch of the Contarini family, members of which twice held office at the mint; the picture was probably commissioned to celebrate Paolo Contarini's tenure in 1558–9. In its original location under the vaulting of the mint, the image of a woman looking at her scales would also have brought to mind the weighing of coinage to assess its worth. Its full message could be interpreted as: 'While a Contarini is in charge, Justice prevails and honest money is assured.'

PRUDENCE

Like all the virtues, whose names are feminine in Latin and Romance languages, Prudence can be depicted as a woman. Her attributes vary, but the most commonly represented are a snake or snakes and a mirror. The snake is derived from the Bible: 'Be ye wise

32

(prudentes) as serpents' (Matthew 10:16), while the mirror signifies either foresight or the ability to see oneself as one really is. Since snakes are also emblems of Envy, and a woman looking in a mirror can signify Vanity or even Luxuria, viewers must decide from the context whether they are looking at a virtue or a vice.

Titian, the greatest Venetian painter of the sixteenth century, may have executed the more idiosyncratic *Allegory of Prudence* [26] in about 1565–70 for his private

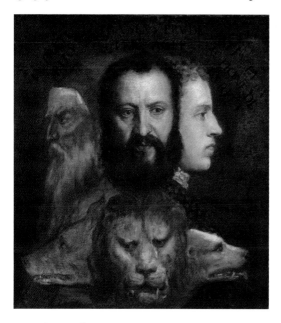

use: the head of the old man on the left resembles the known portraits of the atist in old age. The mature man in the centre may be Titian's son and assistant, Orazio, and the youth on the right a young cousin, Marco Vecellio. Triple human heads had already been used in the Renaissance to express the ideas of time, experience and prudence, and this reading is reinforced by the Latin inscription at the top, arranged to correspond with the heads underneath: 'From the past, the man of the present acts prudently, so as not to imperil the future.'

The monstrously joined heads of a wolf, a lion and a dog below had also come to be associated with time and prudence: the wolf devours the past, the lion is the courage called forth by the present, and the fawning dog lulls speculations about the future.

26. Titian, *An Allegory of Prudence*, about 1565–70, 76.2 × 68.6 cm.

27. Moretto da Brescia, *Portrait of a Gentleman*, 1526, 201.3 × 91.2 cm.

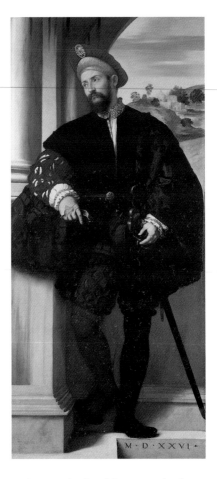

M · D · X X V I ·

Although mainly freshly coined, the medieval imagery of virtues and vices co-opted pagan myth as well as the Bible and the writings of the Church fathers. Fortitude, the cardinal virtue signifying courage, strength and endurance, could be exemplified by either the Old Testament heroine Judith or the Old Testament strongman Samson; the latter, however, was often confused or conflated with his mythological counterpart, Hercules. Fortitude could also be personified as a woman, sometimes in armour, carrying a club and accompanied by a lion (or draped in the pelt of a lion), since a lion, the bravest of all beasts, was slain by both Samson and Hercules.

By analogy, or perhaps in memory of Samson's dying feat of pulling down the pillars of the Philistine temple, Fortitude was also often shown with a whole or broken

28. Master of the Mansi Magdalen, *Judith and the Infant Hercules*, probably about 1525–30, 89.5 × 52.7 cm.

column. This attribute came to be used in portraits, especially those of men with a military bearing (such as the *Portrait of a Gentleman* of the Avogadro family [27] by the Brescian painter Moretto), to indicate the sitter's own courage and power of endurance.

A most unusual representation of Fortitude was painted around 1525–30 by an unidentified Netherlandish artist, the so-called Master of the Mansi Magdalen [28]. It depicts Judith with the head of Holofernes, and Hercules as an infant, strangling the snakes who came to smother him in his cradle. Both are naked – Hercules in the tradition of ancient art, and Judith to underline her allegorical role. Although its general meaning is clear, the painting has long puzzled scholars: why are both Judith and Hercules represented, and why is the latter shown as a baby? Dr Elizabeth

McGrath of the Warburg Institute has proposed that the picture illustrates an idea first found in an ancient Roman treatise on oratory, and repeated in the sixteenth century by Erasmus: that an exemplary deed is most effective when performed by an inferior person, even 'a weak woman'. The painter goes one better, showing the two naturally weakest beings, a woman and a child. Both have performed exemplary deeds of courage and strength. It is unlikely that the idea was the artist's own, and the picture may have been commissioned by a learned patron.

THE CARDINAL
VIRTUES
AND TRUTH

Personifications of all four cardinal virtues take part in the charade painted in 1733 by the fashionable Parisian artist Jean-François Detroy [29]. The subject of this large canvas executed for an unknown patron, *Time unveiling Truth*, derives from the ancient saying '*Veritas filia temporis*' – 'Truth is the daughter of Time' (that is, truth will out in time).

29.
Jean-François
Detroy,
*Time unveiling
Truth*, 1733,
203 × 208 cm.

Detroy points up the principal theme by contrasting Truth with Falsehood: simpering Truth is shown removing

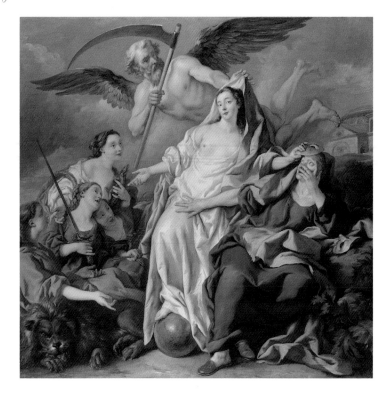

a youthful mask from the face of an elderly woman in house slippers, the personification of Fraud. With her right hand Truth points to the admiring quartet of Prudence with her serpents, Temperance holding a pitcher of water with which to dilute her wine, Justice with sword and scales, and Fortitude with her lion. Truth rests her foot on the globe, to indicate either that she is above the things of this world, or, as seems more likely here, that in time she will conquer the world.

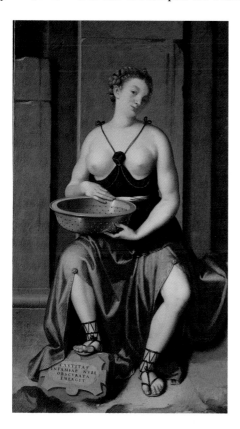

30. Giovanni Battista Moroni, *Chastity*, probably about 1555–60, 153.3 × 87 cm.

Although not one of the canonical seven, chastity was an oft-represented virtue. Defined as virginity before marriage and faithfulness within it, chastity was sometimes exemplified, as in this picture of about 1555–60 by Giovanni Battista Moroni, through the legend of Tuccia [30]. A priestess in the temple of Vesta, Roman goddess of the hearth and its fire, Tuccia was falsely accused of breaking her vows. To prove her innocence, she carried a sieve full of water from the

Tiber to the temple. The Latin inscription – which can be translated as '[Her] Chastity, obscured by a cloud of infamy, shines forth' – more or less quotes the Latin writer Valerius Maximus' introduction to the story. Tuccia's bared breasts, so inappropriate to the tale in the eyes of a twenty-first-century viewer, are Moroni's nod to the antique, and probably also to his allegorical intention. More frequently, however, chastity was one of the virtues defined through their contrasting vices. Just as Industry is the opposite of Sloth, so Chastity is the perennial antagonist of Eros; in this guise she will appear in the discussion of the vices below.

THE VICES

Few vices have entered the National Gallery. A small allegorical painting [31], one of many copies of a famous drawing by Michelangelo, *Il Sogno' (The Dream Of Human Life)* of the 1530s, represents six of the Seven Vices or Deadly Sins through small-scale groups of figures in the background. Clockwise from the lower left they enact scenes of gluttony, lust, avarice, anger, envy and sloth (only despair is omitted). They are the subject of the young man's dream, from which he is

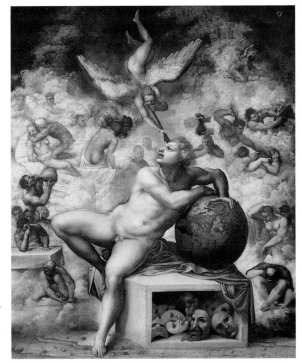

31. After Michelangelo, *The Dream,* after 1533, 65.4 × 55.9 cm.

awakened by the trumpet of the flying figure of Fame or Emulation. The masks below are the usual symbols of deceit. The moral of the allegory as a whole seems to be that he who would achieve fame must not let himself be diverted by worldly and sensual preoccupations.

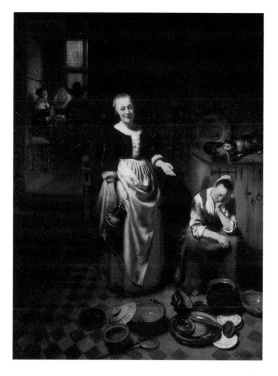

32. Nicolaes Maes, *Interior with a sleeping Maid and her Mistress* (*'The Idle Servant'*), 1655, 70 × 53.3 cm.

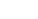

The vice most often represented in the Collection is idleness or sloth. From medieval times, it was thought to comprise two elements: simple physical laziness, *pigritia* or *desidia*, and mental inactivity leading to melancholy, *acedia*, sinful because implying a loss of faith. Represented as a seated woman, dozing or daydreaming with one hand in her lap and the other supporting her head, or with both hands folded, idleness is frequently depicted in Netherlandish and Dutch prints and appears repeatedly in the seventeenth-century Dutch paintings of 'everyday life' intended for 'instruction through laughter' in the home.

In Nicolaes Maes's *Interior with a sleeping Maid and her Mistress* [32], painted in 1655, idleness is either personified by or exemplified in the maid, who leaves her dishes unwashed and allows the cat to steal a roast

chicken. In the room beyond, the company play cards; the smiling housewife may have come into the scullery to replenish the wine. The picture is intended to evoke different reactions in male and female viewers: men may look on with mere amusement, women are expected to be shamed into forsaking idleness for industry.

A more complex comical counter-example is presented by Jan Steen about ten years later in the *Effects of Intemperance* [34], which might better be entitled *Sloth and its Consequences*. A Dutch Catholic, Steen painted

33. The Mistress of the House, detail of 34.

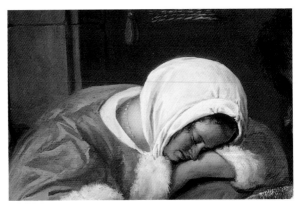

34. Jan Steen, *The Effects of Intemperance*, about 1663–5, 76 × 106.6 cm.

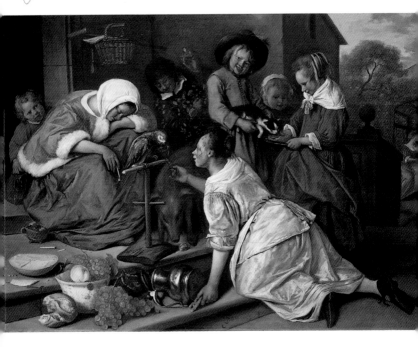

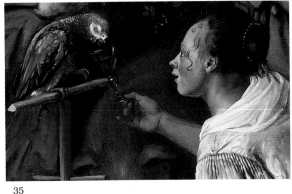

35

36

many biblical scenes and even some mythological ones, but he has become a byword for his domestic paintings of dissolute households – an 'upside-down' world.

As in many of these pictures, the moral here is that adults' vices endanger the future of children, natural mimics like the parrot being offered wine by the over-dressed and drunken maid [35]. By analogy with a contemporary moralising print alluding to a children's game, the pretzel she holds symbolises the tug-of-war for her soul between God and the Devil.

The root cause of disorder, however, is the mistress of the house [33]. Slumped in the traditional pose of Sloth, she has been wasting her days in smoking, and is now sleeping off the effects of alcohol. One of her neglected children steals from her purse. While others squander a good meat pie on a cat, the eldest boy epitomises foolish behaviour: he is 'casting roses before [a] swine' [36], as the Dutch proverb has it. In the background an older man, perhaps the householder, is wining, dining and making love to a young woman.

Hanging over the scene is a basket with a birch and a leprous beggar's crutch and clapper [37], which await the idler, the drunkard, the thief and the wastrel. It has been argued that such Dutch paintings are not, strictly speaking, allegories, but their relation-ship to the genre is evident, not least in their illustration of adages and proverbs.

37

W hile seventeenth-century Dutch housewives were admonished not to be idle, Italian Renaissance brides were more often commanded to be chaste.

In Italian domestic decoration, the imagery of the vice of erotic love and of its contrasting virtue, chastity, was decisively influenced by a series of six famous allegorical poems, the *Trionfi*, or *Triumphs*, by the fourteenth-century Florentine exile Francesco Petrarca. Drawing on the ancient Roman custom of honouring victorious generals with a triumphal procession, Petrarch's *Trionfi* describe the Triumph of Eros, followed by the Triumphs of Chastity over Eros, of Death over the living, of Fame over Death, of Time over Fame and of Eternity (or Divinity) over Time. The theme became generally available to artists when the first illustrated editions of the poems were published in the fifteenth century.

38. Workshop of
Apollonio di
Giovanni and
Marco del Buono,
*The Triumph of
Love*, probably
1453–5(?),
68.7 × 69.1 cm.

THE TRIUMPH OF EROS

T he Triumph of Eros is the subject of a birth tray – of the type originally used in Florence to bring gifts of food to women after childbirth – painted around

1453–5 by the Workshop of Apollonio di Giovanni and Marco del Buono [38]. Atop his triumphal car and accompanied by a large cortège of young Florentines, Eros demonstrates his power over men. In the foreground Delilah, the Old Testament temptress, cuts Samson's hair, the prelude to his destruction. Following a medieval legend not cited by Petrarch, the ancient Greek philosopher Aristotle is bridled and ridden by Phyllis, the courtesan with whom he is besotted.

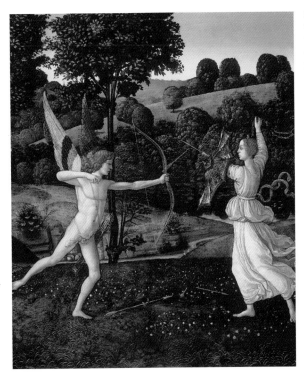

39. Gherardo di Giovanni del Fora, *The Combat of Love and Chastity,* probably 1475–1500, 42.5 × 34.9 cm.

The little panel [39] of around 1475 by Gherardo di Giovanni depicts the combat of Eros and Chastity from the second of Petrarch's *Triumphs.* Eros is shooting arrows at Chastity, embodied by Petrarch's beloved, Laura. She holds a shield, upon which his golden arrows break, and a chain by which Eros is destined to be bound. Another painting by the same artist, *Eros Bound on the Car of Chastity,* now in Turin, continues the story. They may have formed part of the decoration of a piece of furniture.

THE COMBAT OF EROS AND CHASTITY

The Triumph of Chastity: Love Disarmed and Bound [40] was painted around 1509 by Luca Signorelli as part of the mural decoration of a room in the Palazzo del Magnifico, Siena, for the wedding of Pandolfo Petrucci, the city's ruler. While Chastity/Laura binds Eros, two heroically chaste wives of antiquity – Lucretia, who killed herself after being raped, and Penelope, who deceived her suitors to remain faithful to Ulysses, her long-absent husband – pull out Eros's feathers and break his bow. The Roman soldiers probably include Caesar and Scipio, exemplars of male chastity. The Capture of Love, and Chastity on her triumphal chariot, can be seen in the background.

40. Luca
Signorelli,
*The Triumph
of Chastity:
Love Disarmed
and Bound,*
about 1509,
125.7 × 133.4 cm.

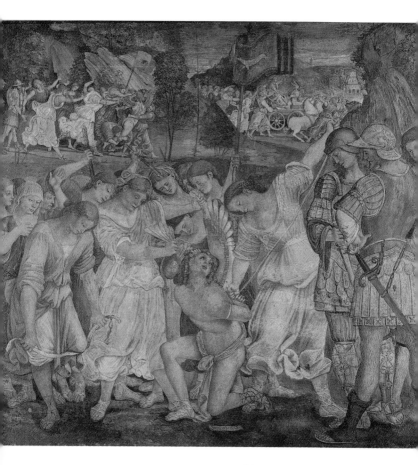

THE LIBERAL ARTS

The Seven Liberal Arts – the literary trio, or *trivium*, of Grammar, Logic and Rhetoric, and the mathematical quartet, or *quadrivium*, of Geometry, Arithmetic, Astronomy and Music – formed the core of secular learning in the Middle Ages. Although not devoted to Christian subjects, these disciplines were held in high regard by the Church, for some centuries the only institution of teaching and scholarship, as weapons against heresy, which was thought to arise out of ignorance. The Liberal Arts were often depicted together with the Seven Virtues, and sometimes even conflated with them. The tradition of personifying them as women, in accordance with the feminine gender of their Latin names, originates in a fifth-century treatise, Martianus Capella's *The Marriage of Philology and Mercury*. The personifications might be accompanied by anonymous or well-known practitioners of their Art: Euclid, for example, was often shown with Geometry.

Two panels [41 and 42] depicting the enthroned Rhetoric (or another of the bookish Arts of the *trivium*) and Music, each receiving homage from a male devotee, were painted about 1480, probably by the expatriate Netherlander Justus of Ghent and Workshop, for a *studiolo* of Federico da Montefeltro, Duke of Urbino and commander of the papal armies, as recorded in the Latin inscriptions.

RHETORIC AND MUSIC

A *studiolo* was a small, secluded room to which a prince could retire to read, listen to poetry or music, admire beautiful objects and, free of court protocol, entertain learned men as friends. Such rooms were appropriately decorated, often with representations of the Liberal Arts or, from the mid-fifteenth century, the Nine Muses, who presided over the arts in Graeco-Roman mythology. The National Gallery's pictures probably come from a *studiolo* in the Montefeltro palace at Gubbio, dismantled long ago, whose wonderful marquetry panelling has been reassembled at the Metropolitan Museum in New York. The steep perspective of the paintings, designed to be seen from below, shows that originally they must have been placed

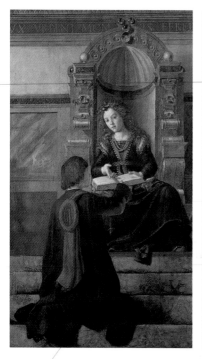 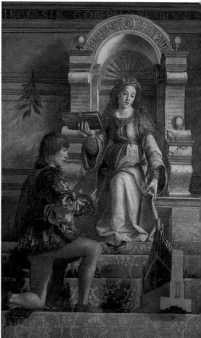

above the marquetry, as were the painted decorations of the surviving Montefeltro *studiolo* at Urbino.

Music [42] is identifiable by the portative organ with which she endows the richly dressed young noble, a courtier, or, as has sometimes been suggested, Federico's young brother-in-law, Costanzo Sforza, Lord of Pesaro. A branch of laurel, the evergreen tree associated with Apollo, god of music and poetry, hangs on the wall behind him.

In contrast with his flashier colleague, the kneeling youth receiving instruction from Rhetoric or one of her sisters wears sober academic or notary's garments.

Some 70 years later, in 1650, Laurent de La Hyre decorated the study of a Paris town house with personifications of the Liberal Arts, according to their descriptions in Cesare Ripa's *Iconologia* (see p. 13). Like the panels attributed to Justus of Ghent and Workshop, La Hyre's seven canvases, now dispersed in various collections, were probably set above the viewer's head, incorporated into the room panelling.

The National Gallery's Grammar [43] is a stately figure, an ancient statue dressed in shot silk. She is watering flowers, according to Ripa's prescription: 'Like young plants, young brains need watering and it is the duty of Grammar to undertake this.' As if to stress the contrast between her classical appearance and her homely action, the lovingly observed primulas and anemones, in their modern flowerpots, are set on an ornate fragment of ancient masonry. In the background grand fluted columns and a Roman urn close off our view into the garden. The Latin legend on the ribbon wound about Grammar's arm can be translated as 'A learned and articulate word spoken in a correct manner'. Her function among the Liberal Arts was not to parse sentences or teach conjugations, but to ensure that ideas could be communicated clearly and effectively.

43. Laurent de La Hyre, *Allegorical Figure of Grammar*, 1650, 102.9 × 113 cm.

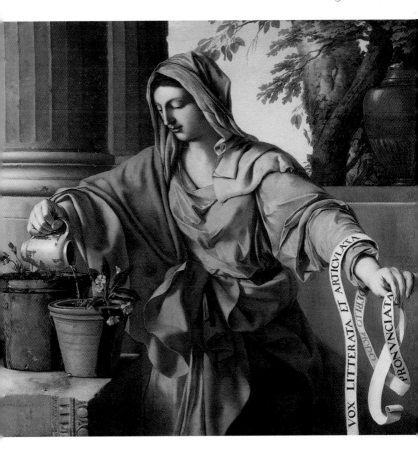

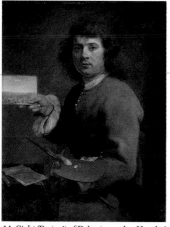 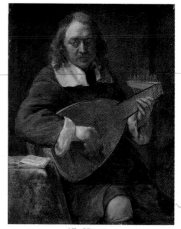

44. *Sight (Portrait of Robert van den Hoecke)* 45. *Hearing*

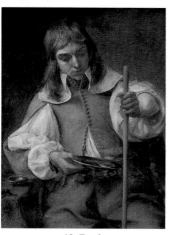 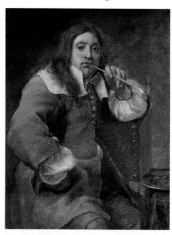

46. *Touch* 47. *Smell (Portrait of Lucas Fayd'herbe)*

44–47. Gonzales Coques,
before 1661, 25.1 × 19.4 cm.

48. After Gonzales Coques,
after 1661, 25.3 × 19.4 cm.

48. *Taste*

48

THE FIVE SENSES

The Five Senses, sight, hearing, touch, smell and taste, popular in the seventeenth century, were often related to the arts, though not necessarily to the Liberal Seven.

In this series of the Five Senses [44–48], executed about 1655–1660, the Fleming Gonzales Coques used the allegorical device to portray some of his friends. *Sight* is represented by a painter, Robert van den Hoecke, who became Controller of Fortifications – hence the plan and his sword of office. *Hearing,* the lute player, may also have been a painter, the specialist in flower pieces Jan Philip van Thielen. *Touch,* an unknown young man, is letting blood from his arm, a contemporary medical practice. (In other series, the sense of touch is represented by a crab or lizard's bite, which is why some people think it is the subject of Caravaggio's *Boy bitten by a Lizard* [49]). *Smell* is a portrait of Lucas Fayd'herbe, a sculptor and architect and one of Rubens's last pupils. *Taste* is a copy by an unknown imitator, substituted for Gonzales Coques's lost original.

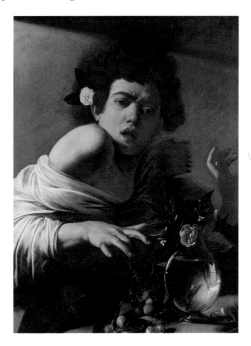

49. Michelangelo Merisi da Caravaggio, *Boy bitten by a Lizard,* 1595–1600, 66 × 49.5 cm.

TIME

THE SEASONS
AND THE
AGES OF
HUMANKIND

Two contrasting notions of time coexist in the Western tradition: linear, in which time is thought to flow from beginning to end, and cyclical, in which there is no past or future but only eternal return. The personification of Time as a winged old man with hourglass and scythe corresponds to a linear definition, as do serial images exemplifying the various stages of human life from infancy to old age. The cyclical concept is illustrated through the recurring occupations of the months or seasons. These two allegorical modes may be combined, so that the year's end, winter, is depicted as an old man – linking the cycles of nature to the life of humankind. This is the tradition followed by the seventeenth-century Flemish painter David Teniers the Younger in these four small pictures on copper [50–54].

Despite looking as though they were painted from life, Teniers's *Spring* and *Summer* are indebted more to Pieter Bruegel's engravings of the seasons, dating from the 1550s, than to direct observation. In *Spring* tender potted plants are brought out of doors, and parterres laid

50–54.
David Teniers
the Younger,
about 1644.

50. *Spring*, 22.1 × 16.5 cm. 51. *Summer*, 21.9 × 16 cm.

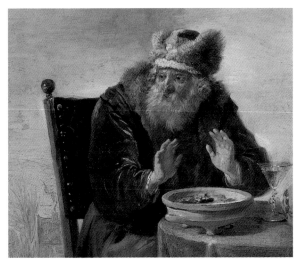

out and planted. *Summer* is harvest time. *Autumn* is associated with wine-making.

While the main characters in these three pictures exemplify seasonal occupations, the old man warming himself over a brazier [52] is the very personification of Winter; behind him, youths are sporting on the ice. This tradition is not confined to northern Europe.

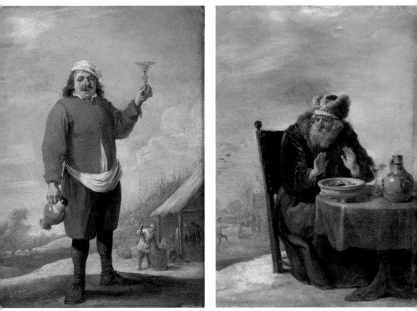

53. *Autumn*, 22.1 × 16.4 cm. 54. *Winter*, 22.1 × 16.2 cm.

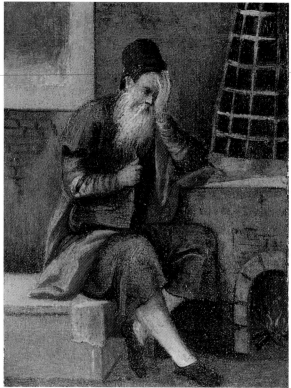

55. January, detail from *The Labours of the Months*, early 16th century, 13.3 × 10.2 cm, in the style of Bonifazio di Pitati.

A similar old man [55] warming himself by the stove represents the month of January in a series of twelve small pictures, originally mounted in a piece of furniture, by a follower of Bonifazio di Pitati, an artist working in Venice in the early sixteenth century.

The French painter Puvis de Chavannes executed large easel pictures in oils intended to evoke Italian fifteenth-century frescoes. The National Gallery's *Summer* [57] is a study for a large painting of this kind dating from 1873 and now at the Musée d'Orsay in Paris.

Although the wheat harvest is taking place in the background, the classical dress, or state of undress, of the foreground figures and the emphasis given to leisure seem to suggest the vision of a primeval Golden Age more than the recurring occupations of the months. The Four Ages of the World were described by the Latin poet Ovid in descending order of happiness and innocence: from the Golden Age through the Ages of Silver, Bronze and Iron.

56. Detail of 57.

57. Pierre-Cécile
Puvis de
Chavannes,
Summer,
before 1873,
43.2 × 62.2 cm.

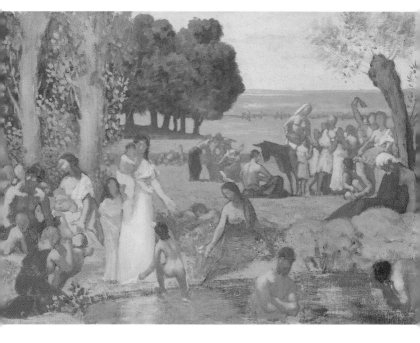

The stages of human life from infancy to senescence
have been variously computed as ten, seven, five or
three (as in Titian's *Prudence* [26]). But they are most
often represented as four, perhaps to stress a comparison
with the seasons and suggest the cyclical renewal of
the life of the species, if not of the individual. We speak
of youth as 'the springtime of life' as readily as of 'Old
Man Winter'.

The Ages of Humankind are also often conflated
with the Times of Day, in which morning equals youth
and evening, or night, old age. The eighteenth-century
Parisian painter Nicolas Lancret, however, treated the
stages of life and the times of day separately in these two
series of small domestic pictures.

Lancret relates the four Ages of Humankind to the
recreations of a highly idealised contemporary French
society [58–63]. *Childhood* is a time for play; the toddler's
walking frame is transformed into a precarious carriage.
The setting evokes a grand summer house, where
only the adults, nurse and toy seller are not to the
manor born.

Youth shows the toilette of beautiful young women
attended by a noble gallant. He is distracted by the

58–63. Nicolas
Lancret, *The Four
Ages of Man*,
1730–5.

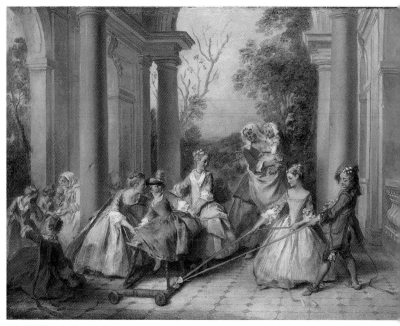

58. *Childhood*, 33 × 44.5 cm.

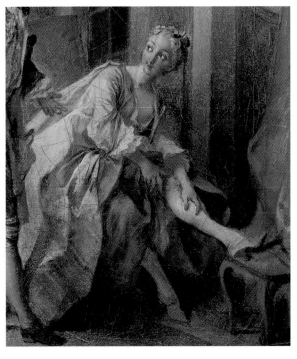

59. Detail of 60.

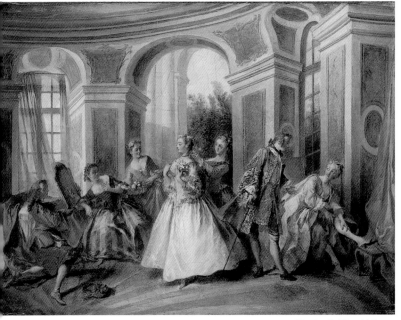

60. *Youth*, 33 × 44.5 cm.

61. Detail of 62.

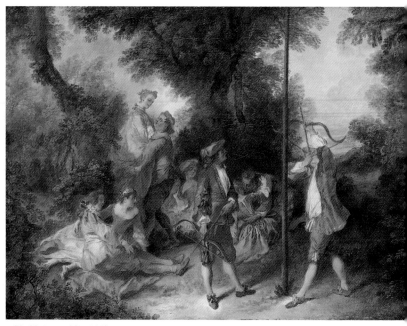

62. *Maturity*, 33 × 44.5 cm.

charms of the seated girl drawing on her stockings, while a more modest young man holds up the mirror to a girl being adorned with flowers. The flower seller is no less charming than the others, and it is not clear whether the girl seated at the left is a maid or a mistress.

In *Maturity* consummated sex replaces the mere flirtations of youth, and the setting changes from boudoir to greenwood, where 'a-hunting [men] will go'. Two are shooting arrows at a live bird – fluttering mercifully out of our sight – tethered to the pole in the foreground. This was a real pastime, but Lancret means to recall the metaphor of 'love's arrows', or perhaps even suggest a more explicit phallic symbolism. A third man is carrying his human prey off behind the trees. The advances of a fourth are being repulsed, at least for the moment: two unpaired girls and a harmonious couple watch in sympathy

Old Age is the only one of the series to be lived out by common folk, not in parkland but in a village garden. Even here the appearance of a pert young maid rouses the old Adam. Lancret's *Four Times of Day*

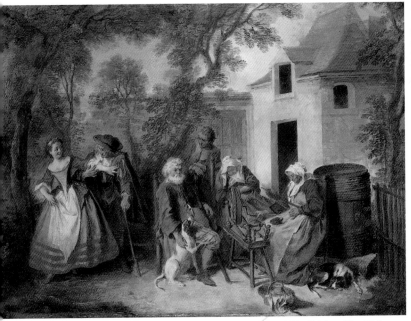

63. *Old Age*, 33 × 44.5 cm.

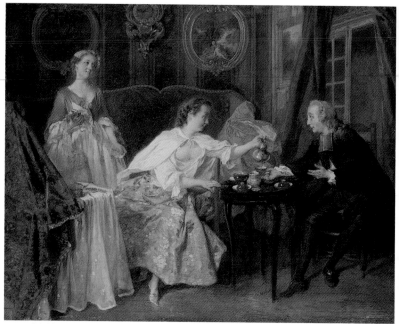

64. *Morning*

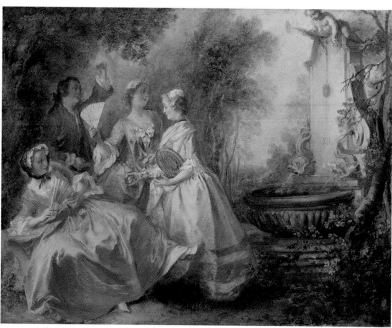

65. *Midday*

64–69.
Nicolas Lancret,
*The Four Times of
the Day*, 1739–41,
28.9 × 36.8 cm.

66. Detail of 65.

[64–69] are also exemplified through the playful activities of the leisured classes. *Morning* shows a young woman *en déshabille* sharing breakfast with a worldly young cleric – personages of contemporary comedy. The clock stands at about eight minutes past nine. A contemporary visitor to the Paris Salon of 1739 where the picture was exhibited commented: 'This young person, with her bodice nonchalantly thrown open and her dressing gown thrown back…pours tea into the cup that M. l'Abbé holds out to her with a distracted air; because he is attentive only to this beauty's disarray. A maid takes it all in, smiling slyly.'

At *Midday* a young man and his three female companions, who have been picking flowers in an idyllic garden, stop by a sundial to check their watches. In the

67. Detail of 68.

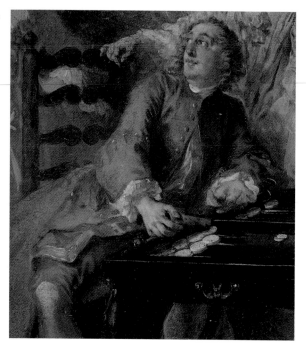

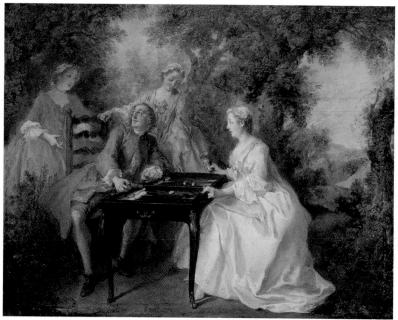

68. *Afternoon*

Afternoon, these same figures settle down to a game of backgammon. In the *Evening*, five modern nymphs bathe by moonlight, espied by the viewer. But in Lancret's light-heartedly decadent world, the spectator can safely play the Peeping Tom – unlike Ovid's Actaeon, who, stumbling upon Diana and her nymphs bathing in a clearing, was changed into a stag and devoured by his own hounds.

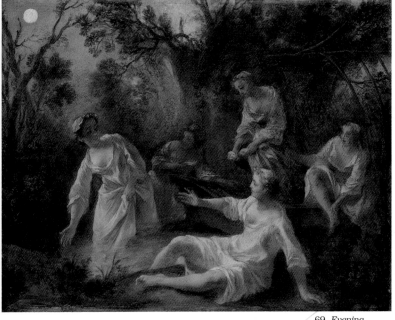

69. *Evening*

CONCLUSION

Whether serious or frivolous, designed as riddle or propaganda, or for private viewing in the boudoir, allegory has been a pictorial mode favoured over many centuries. It survives today, more vigorous than we usually realise – if not in the artist's studio, then in heraldry and its progeny: stamps, coins and medals, and marketing. Justice still brandishes scales and sword; Britannia still rules the waves; France/ Marianne/Liberty still mounts the barricades; Uncle Sam still wants YOU. Most pleasing of all, Mercury of the winged sandals, eloquent messenger of the gods, will swiftly deliver flowers to our loved ones around the world: he is the trademark of Interflora. The firm's slogan, 'Delivered straight to the heart', echoes the sentiments of painters through the ages.

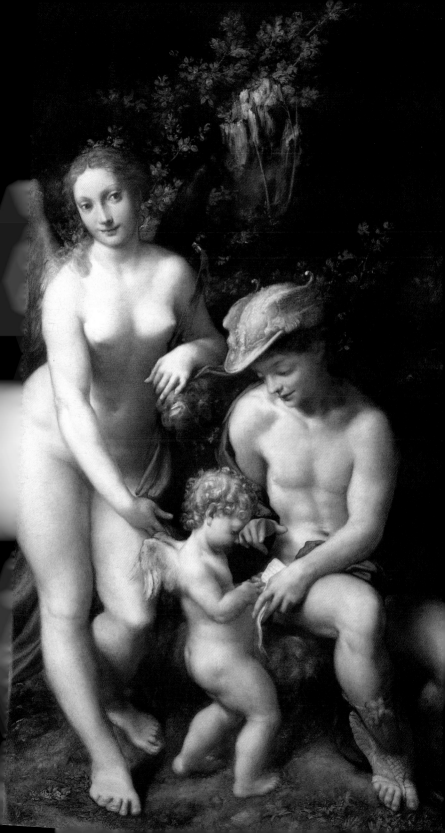

FURTHER READING

Of the many specialised studies, the most readily available are:

'Allegory' (with extensive bibliography) in
The Grove Dictionary of Art
ed. Jane Turner,
34 vols, Macmillan, London 1996.

E.H. Gombrich,
Symbolic Images:
Studies in the Art of the Renaissance
Phaidon Press, London 1972, reprinted 1996.

For subject matter and symbolism see:

James Hall,
Dictionary of Subjects and Symbols in Art
rev. edn, John Murray, London 1993.

For mythological narrative see:

Anabel Thomas,
An Illustrated Dictionary of Narrative Painting
John Murray, London 1993.

PICTURE CREDIT

19. Musée du Louvre © RMN, Paris. Photo: C. Jean